OREGON

The Art of Amanda Snyder & Jefferson Tester

ORIGINALS

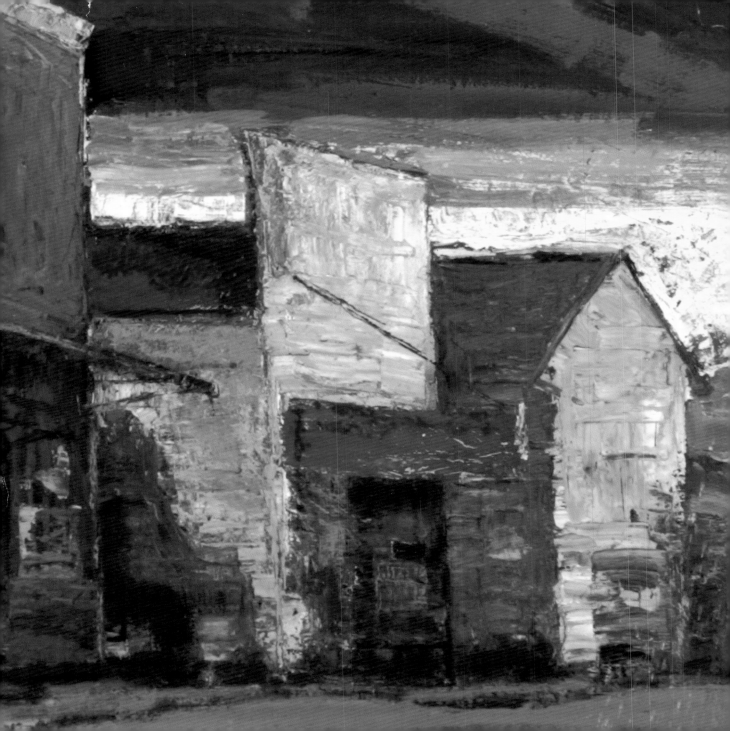

OREGON

THE ART OF AMANDA SNYDER & JEFFERSON TESTER

ORIGINALS

Edited by

Robert L. Joki

Marsha T. Matthews

Oregon Historical Society, Portland
2006

Acknowledgements

When Eugene Snyder called me last year to ask about the use of Jefferson Tester's portrait, little did I know that an exhibit and this publication would be the result. But he said that we were "simpatico" and that working on an exhibit of his mother's and his uncle's art would be a wonderful project. And couldn't we just do a small publication to accompany it?

And so, with the approval of OHS Executive Director John Pierce and the OHS Board's Collections Committee, we embarked on the adventure. Without Eugene's dogged determination and Robert Joki's knowledge of local art collectors, the exhibit and the book would not exist. I would also like to acknowledge the OHS Press who answered my questions and edited text with speed and accuracy.

I want to thank the lenders of the artworks to the exhibit, Daniel Berman, Brian and Gwyneth Booth, Brooks and Dorothy Cofield, Michael W. Foster (Astoria), John Gray, Bonnie and Roger Hull, Harvey and Jody Klevit, Hal and Jeanyse Snow, Sovereign Gallery, William & Ann Swindells, as well as those lenders who wish to be anonymous. I also extend my appreciation to the underwriters of this publication for their generous support: Brian and Gwyneth Booth, Brooks and Dorothy Cofield, Michael W. Foster (Astoria), John Gray, Jeff Johnson (Morgan Stanley), Arthur L. Joki, Mary F. Joki, Robert and Susan Joki, Murdoch Collection, Ingolf Noto, and Eugene Edmund Snyder.

MTM

Cover Left
AMANDA SNYDER (SELF-PORTRAIT), 1949
Amanda Snyder
Construction on board, 27" x 22"
Collection of the Oregon Historical Society

Cover Right
SELF-PORTRAIT, 1943
Jefferson Tester
Oil and palette knife on board, 19" x 15"
Collection of the Oregon Historical Society

Previous Page
EASTERN OREGON, ca. 1965
Jefferson Tester
Oil on canvas, 22" x 30"
Collection of Brian and Gwyneth Booth

Printed in the United States of America
Design by Bryan Potter Design
Printed by Millcross Litho
Photography by Scott Rook

Snyder, Amanda.
 Oregon originals : the art of Amanda Snyder and Jefferson Tester / edited by Robert L. Joki, Marsha T. Matthews. p. cm.
 Exhibition catalog.
 ISBN-13: 978-0-87595-304-5, ISBN-10: 0-87595-304-2
 1. Snyder, Amanda — Exhibitions. 2. Tester, Jefferson, 1899-1972 — Exhibitions. I. Joki, Robert. II. Matthews, Marsha T. III. Tester, Jefferson, 1899-1972.
 IV. Title.
 ND237.S6325A4 2006
 759'.195 — dc22
 2006013621

Printed on recycled paper

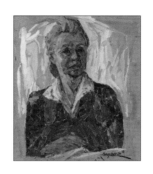

A M A N D A S N Y D E R *1894-1980*

J E F F E R S O N T E S T E R *1899-1972*

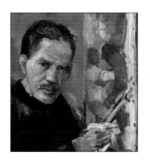

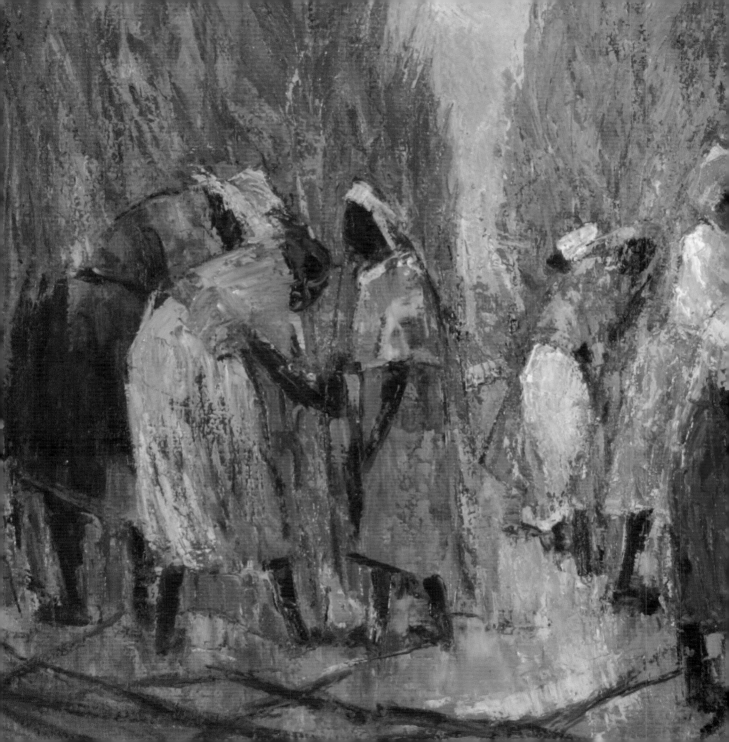

Introduction

By Robert L. Joki
The Sovereign Gallery

When American art took its first monumental leap into the "modern" at the landmark Armory Show in New York City in 1913, two teenagers were quietly developing their individual artistic talents in the railroad and sawmill town of Roseburg Oregon.

Jefferson and Amanda Tester were probably unaware of the controversy that the Armory Show caused in the New York press and with the public, as young European artists such as Marcel Duchamp, Vasily Kandinsky, Pablo Picasso, Henri Matisse, and Edvard Munch joined forces with some of America's pioneers in modern art — such as John Sloan, Walt Kuhn, and Arthur B. Davies — to mount an art exhibit that would rock the foundations of American taste and culture.

Throughout their lives, Jeff and Amanda would pursue similar but separate paths to find their respective places in this same world of international modernism. Their stories can be told through their differences, but they should be marveled at for their similarities.

Both stories begin in the public school system of Roseburg, Oregon. Amanda said that she became serious about her artwork at age 9 while in the third grade. By the time of her marriage and move to Portland at age 22, she had created some fine early works. Jeff's early work impressed his teachers, and, after graduating from high school, he was able to study at a San Francisco art school for a year. This subtle distinction between Amanda's move north and Jeff's move south would provide a far greater difference than geography and would continue to define their individual artistic paths throughout their lives.

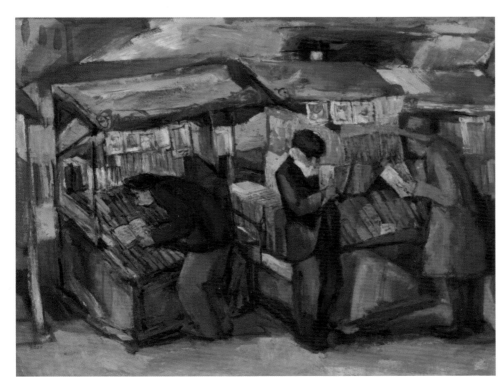

BOOK STALL, 1952
Jefferson Tester
Oil on canvas, 25" x 30"
Private Collection

Previous Page
CANE CUTTERS – CUBA, 1954
Jefferson Tester
Oil on canvas, 24" x 30"
Collection of Brooks & Dorothy Cofield

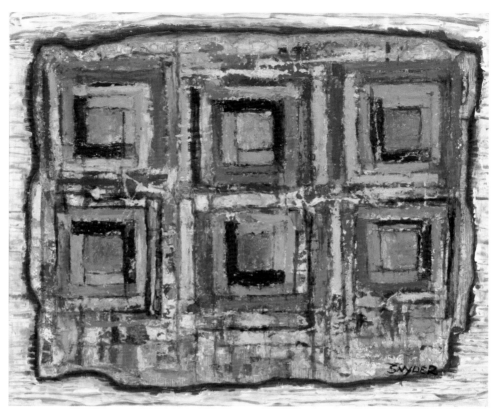

Amanda pursued her vision in Portland by taking some courses at the newly formed Museum Art School. Her life as a homemaker — and eventually a mother — was never at odds with her desires to develop her talents as an artist. Her husband, Edmund Snyder, provided a simple, but comfortable and stable life for the family.

After Jeff's year at the San Francisco School of Art, he returned to Portland and joined the art department of *The Oregonian*, a job he held until 1926.

In 1925, both Amanda and Jeff studied painting with an accomplished traditional-style English portrait painter, Sydney Bell, who had recently emigrated from London. This was the last time they would be under the same academic influence.

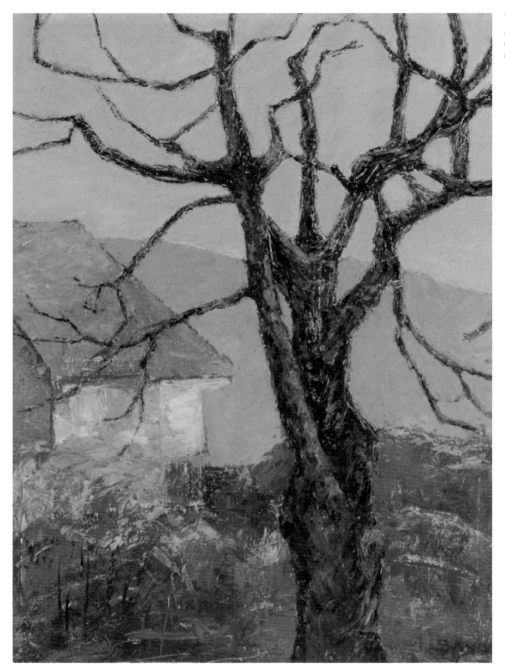

TREE - WEST HILLS, 1944
Amanda Snyder
Oil on canvas, 20" x 16"
Collection of Brian and Gwyneth Booth

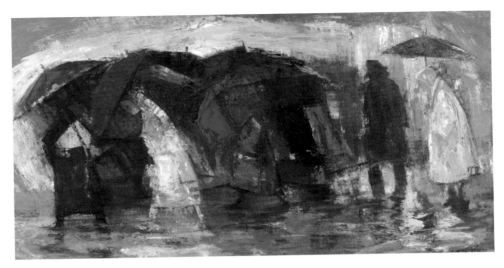

In 1926, Jefferson Tester quit his newspaper job and moved east to join the mainstream of American art education, first with a year at the prestigious Chicago Art Institute and then on to New York to study with Jonas Lie and others. He opened a commercial art firm and received commissions from the most prominent magazine companies of the day, including cover illustrations for *Time* magazine. His paintings were exhibited in Chicago and New York to much acclaim. In 1944, his one-man show at New York's Babcock Gallery brought him to the attention of influential critics, and he was invited to exhibit a painting in the "Critics Choice" show at the home of American modern art, the New York Armory. The *New York Times* called him "one of the ten best American painters."

Jeff left New York intending to paint the world, and he eventually landed in France, where his one-man Paris show at Andre Weil Gallery in 1952 led to glowing reviews in many of the leading French art journals of the day.

Les Arts, 18 Jan.: "We are accustomed to consider that there can be no painting, I mean good painting, outside our country (France), and all too often, alas, exhibitions of foreigners confirm this belief. A brilliant exception comes this week to prove us the contrary. It comes from Jefferson Tester...."

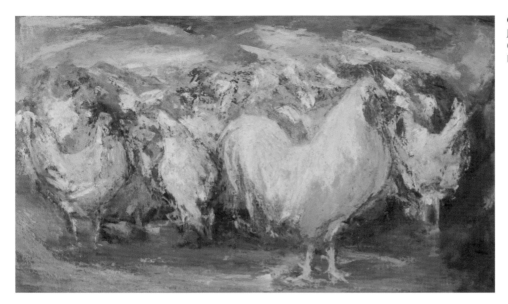

The boy from Roseburg had fulfilled his promise. He had worked hard, studied well, and was now a rising star in the international art world. His style reflected a unique approach to painting — an aggressive but somehow sublime and expressive brushstroke.

This, combined with a moody and rich color pallet, led Tester to a fresh modern style of painting, all the time staying within a relatively realistic, expressionistic, and sometimes cubist framework.

Jefferson's work showed an acute awareness of European trends, but he produced a decidedly "American" style of painting. The figures in Tester's paintings are filled with emotion. They work, they sweat, they pass in the rain. All the time, we as the silent viewers engage the passing moment in a sympathetic, sometimes slightly voyeuristic way. His figures seem somehow unaware of our presence, and even the landscape seems to pass without regard or acknowledgement.

Amanda quietly worked in Portland. She preferred the solitude of her backyard to the fast pace of the city. She was a private person, but her world of solitude was filled with fantasy. Handmade dolls and backyard birds became

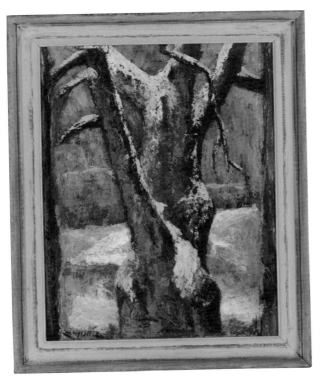

more and more animate, yearning for a human persona — pleading with the viewer for interaction. Amanda's world may have been private, but the subjects in her paintings invite viewers into an intercourse of involvement and discussion.

By 1930, Amanda was already producing richly painted images in unique and experimental styles. Her world may have been small compared to Jeff's, but her circle of influences was large and included most of the significant Portland artists of the 20th century. She chose not to pursue academic study, instead relying on her own interaction with fellow artists for inspiration and direction.

Unlike her brother — who aside from his commercial career, rarely worked outside of his preferred medium of oil paint — Amanda worked in many mediums, including oil, collage, sculpture, and prolific printmaking in woodcut, linocut, and experimental monotypes.

Like her brother, Amanda surrounded her artwork with subtle and well-designed frames that were hand-colored and intended to put each painting in its best light. Much work went into these simple but beautiful frames, which in many cases might be considered works of art in themselves. Her goal was to merge the frame with the image rather than create any issues by its presence.

In 1929, Amanda met probably the single most significant artistic influence in her career — the painter C.S. Price (1874-1950), also a highly private and somewhat reclusive personality. Price, one of the pioneers of the new American painting, was an expressionist whose work became ever more modern and abstract as time went on. Amanda met him at his first exhibition at Meier and Frank Gallery in 1929. He was very impressed with her work and felt a kinship. He sensed that Amanda understood what he was trying to do in his own experimental approach to art. The rich and heavily mottled application of paint and deep painterly qualities in Price's work began to invade Amanda's work as well.

Price took note that Amanda's experimentation in design and her propensity to dark outlines was at times similar to the French painter Georges Rouault's work and suggested that Amanda study his work. Not only did she study Rouault's paintings, she also began a correspondence with the artist that lasted until his death in 1958. Many of her paintings and collages show his influence.

Amanda incorporated many important themes of 20th-century modern art into her painting — from the nonobjective paintings of Vasily Kandinsky to the abstractions of Jackson Pollack. Since she rarely attended art exhibits, more likely she found these influences through books and magazines and even from the television. She was well aware of what was happening outside her small, private world.

Amanda had made a fine reputation for herself, and for nearly five decades her work was included in almost every regional exhibit from Portland to Seattle, as well as an impressive list of one-person shows. The quality of her experimental and modern approach to painting opened the door for her into the male-dominated world of Portland mid-century art.

Jefferson Tester's unique style of modern painting had brought him international fame, but the Roseburg boy longed for the simplicity of life in his home state. His frequent visits to Portland over the years had brought him in touch with many of Portland's modern art pioneers, such as Amanda's friend C.S. Price. The call of Oregon was loud, and it would provide his final artistic destination.

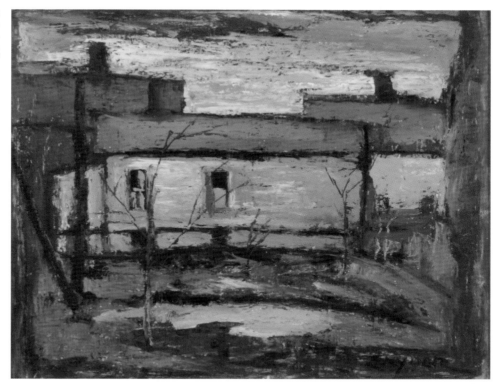

Jeff's years of wandering came to a close in 1963 when he moved to Portland, married his childhood friend Stella, and opened a studio in his Lake Oswego home. He found a ready market for his "society" portrait business, but the Oregon of his youth called his name. He set out to recapture his childhood memories of sawmills and ghost towns — log trucks, churches, clam diggers, and covered bridges.

In contrast to Amanda, whose paintings were included in numerous public exhibitions each year, Jefferson was content simply to paint. He rarely exhibited his work outside his own studio.

The world of brother and sister had gone full circle and reconvened in Portland for the final periods of their lives. This time, Jefferson pursued the privateness and anonymity that would allow him quietly to create a significant body of Oregon work in the last decade of his life. All the while, Amanda's art

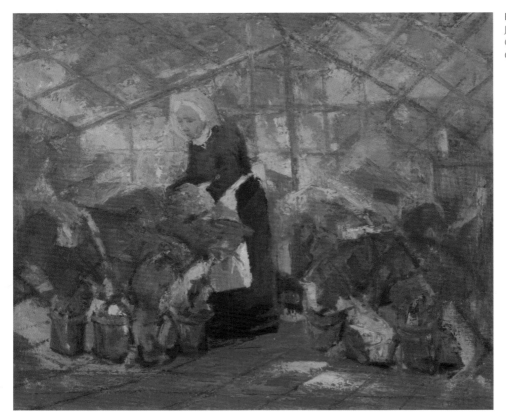

France - Woman in Greenhouse, ca. 195
Jefferson Tester
Oil on canvas, 25" x 30"
Collection of Bill & Ann Swindells

would receive wide recognition for her contributions to Northwest modernism and allow her to secure a significant place in history.

When one looks today at the paintings of Jefferson Tester and Amanda Snyder, together in one room, with the advantage of time for context, they look surprisingly similar. The richly painted, heavily mottled, mostly figurative, always expressive paintings are often housed in handmade frames — each a wonderful example of American 20th-century modernism. One might assume that brother and sister had the same artistic background or had exerted a great influence on each other's development. Instead, the true significance of these artistic lives is found in the way their individual paths and pursuits brought them to such similar artistic solutions.

Each of them — Amanda, the private sister who explored the world through her fantasies, and her worldly brother Jeff, who explored the world first-hand — found individual recognition and success as well as a similar destination in their pursuits of modern 20th-century art.

One went north, the other south — reunited and celebrated as Oregon originals.

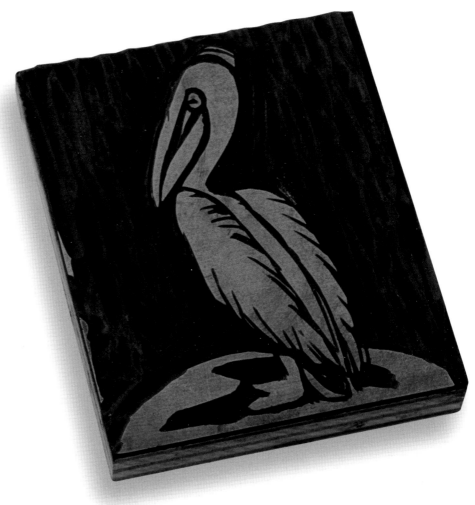

PELICAN, ca. 1960
Amanda Snyder
Linoleum block, 5" x 4" x ⅞"
Collection of the Oregon Historical Society

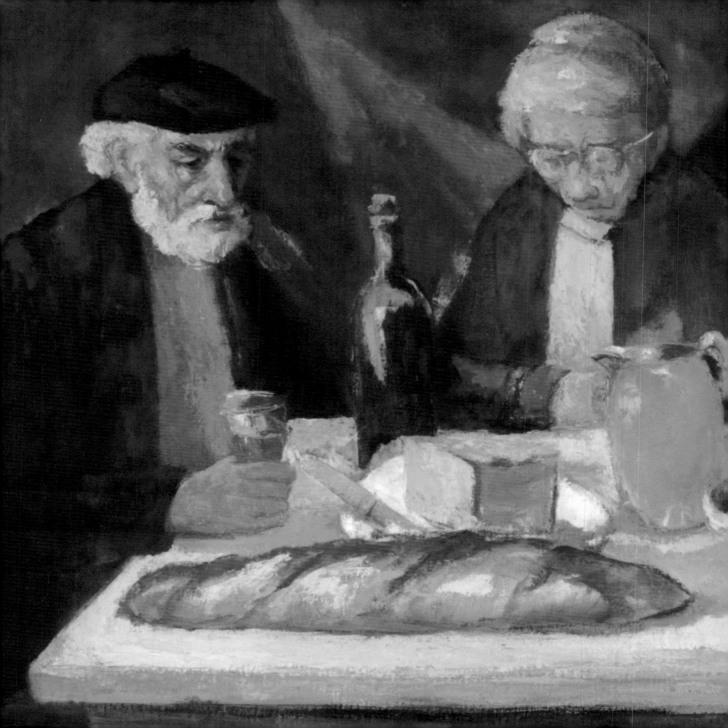

Amanda Tester Snyder and Jefferson Tester

BY EUGENE EDMUND SNYDER

Amanda (Tester) Snyder was born March 15, 1894, near Mountain City, Tennessee, where the eastern tip of the state wedges between North Carolina and Virginia. It is the heart of Appalachia. Her brother, Jefferson, was born June 3, 1899. There were five Tester children: Amanda, Clarence, Vivian, Jefferson, and George Redford.

The Testers were among the earliest settlers, having come from North Carolina shortly after 1800. Their ancestry goes back through colonial days to Sussex County, England. Unlike many people in Appalachia in those days, the Testers could read and write and had some education. The children's father was William Jefferson Tester. His older brother was known as "Squire Tester," and he owned a little country store which was also the post office. He was the postmaster. For a time, the tiny hamlet was known as Testerville.

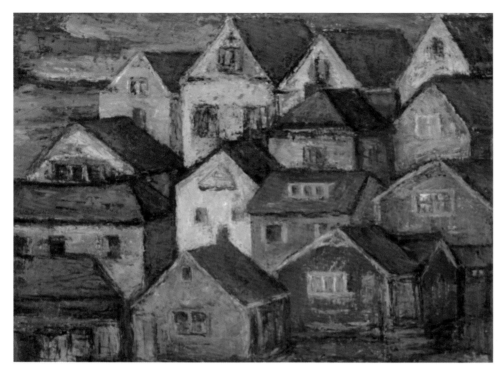

HOUSES ON WEST HILLS, 1960
Amanda Snyder
Oil on board, 22" x 29"
Private Collection

Previous Page
DAILY BREAD, 1952
Jefferson Tester
Oil on board, 28" x 36"
Private Collection

The children's mother, Della Lee Hull, was from middle Tennessee, a more prosperous region. She was quite young when she married, but she had had a relatively good education. As she once expressed it, "I wasn't much, but I was ahead of those mountain people."

Amanda's parents were concerned about their children's future. Their father, though he was tall, thin, and handsome and carried himself with a certain air, had no particular skills. The setting, in the Blue Ridge Mountains, was not without charm, but the terrain was poor, and there were no industries in the region. There seemed to be no future but to live by subsistence farming, in aristocratic poverty. A friend of theirs, a minister, had gone to the West Coast, and his letters told of the greater opportunities there. So the family moved to Roseburg, Oregon, arriving there March 1, 1903.

Years later, Amanda wrote about the train trip west: "It was good to be in the warm railroad coach. There was a coal stove in it, and the smell of burning

SPRINGTIME – I, 1960
Amanda Snyder
Oil on paper, 27" x 23"
Collection of John Gray

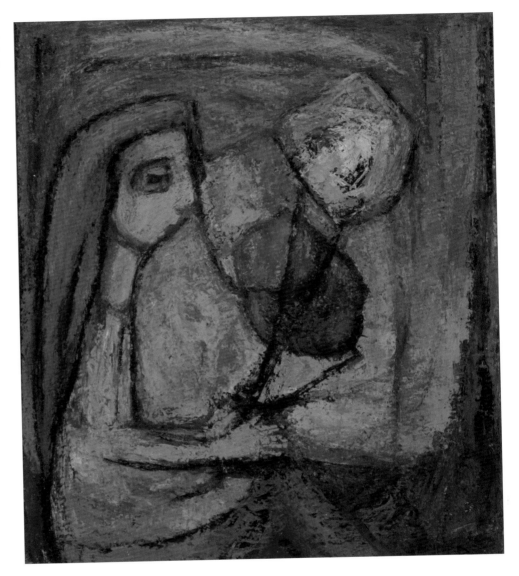

coal was pleasant. We managed to sleep in our red plush seats. We crossed the Mississippi River at night. The electric lights impressed us greatly. They were reflected in golden colors on the water — a memorable sight. We had to change trains at St. Louis. There, I saw cobbled streets for the first time.

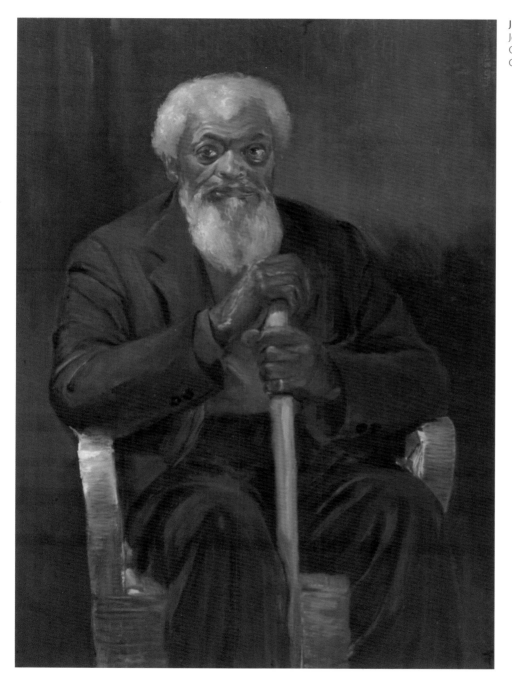

JEFF THOMPSON, PORTLAND, OR., 1942
Jefferson Tester
Oil on canvas, 40" x 30"
Collection of the Oregon Historical Societ

I loved them — their shapes and patterns. Now, when I see cobblestones, a longing comes over me and I feel as if I must walk on them again. We had a fright when we thought the train was leaving without father. He had gone to the station to buy some candy for his five children. The train started, and we all began wailing, 'Pappy's lost, Pappy's lost!' But he had boarded another car in the train and soon joined us. The train trip took seven days. Mother had much to do because there were now five children to look after. I was almost nine, Clarence was eight, Vivian seven, Jefferson nearly four, and Redford was two. Mother at that time was thirty. Spring was wonderful at our new home. The grass was soft and green under our bare feet. The meadow larks sang in the pussy willows, and the hillsides were yellow with buttercups."

But the job opportunities for Mr. Tester were disappointing. He found a job with the railroad, which had a division office at Roseburg, with a round-house and shops. Amanda later remembered those years: "Then father became a city policeman; that was a job for which he was well suited. Later, he had a real estate business, but he never made much money. We had a garden, chickens, and a cow, and we managed with what we had. Mother went to work in a laundry — a humble job, but she was able to adapt to such things and was known and respected in the small town for her strength of character. We all had various jobs. Father died in 1924; he was only 62 years old. When we were looking through his things, we found in the bottom of his old trunk a few dry and twisted tubes of artist's oil paints. Early in life, he had wanted to be an artist, but circumstances never allowed him the opportunity to do that. He had put all that aside and he died with that yearning unfulfilled." The artistic gifts of two of his children, Amanda and Jefferson, must have come from that Tester ancestry.

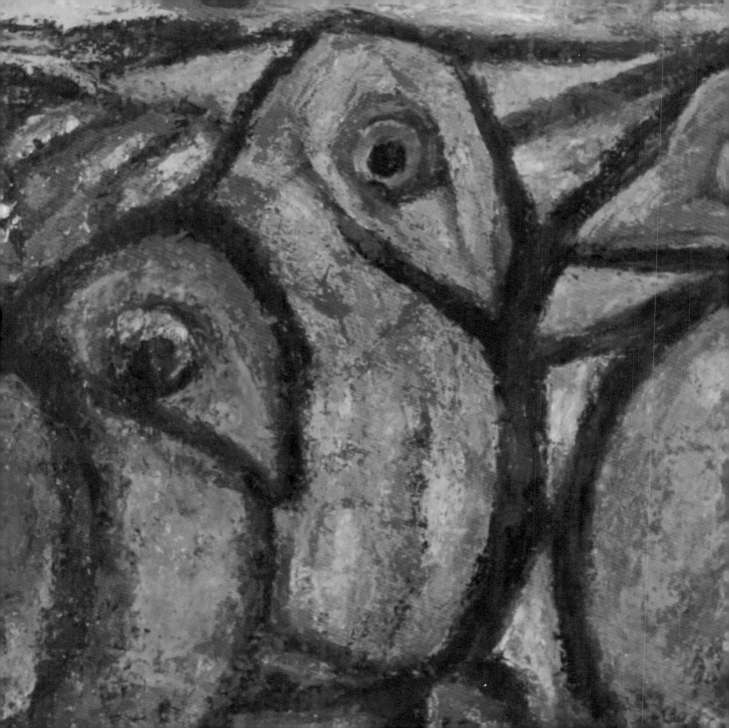

Amanda Snyder

By Eugene Edmund Snyder

EARLY PAINTING

For Amanda, painting was a lifelong vocation. She first began drawing and painting seriously, she liked to say, when she was in the third grade in Roseburg. The teacher was so impressed that she said, "Amanda, you are going to be an artist."

She married Edmund Snyder, a descendant of the pioneer community at Aurora, Oregon, July 16, 1916. She moved to Portland, where Edmund had

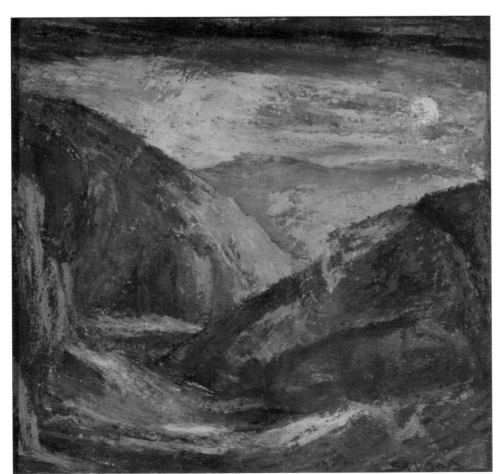

MOONLIGHT, 1945
Amanda Snyder
Oil on board, 22" x 23"
Private Collection

Previous Page
BIRDS IN A GARDEN, ca. 1967
Amanda Snyder
Oil on board, 20" x 30"
Collection of Hal and Jeanyse Snow

begun a lifelong career as an accountant. There, during 1917, Amanda took some lessons at the Portland Art Museum school. In her early paintings — most of which were representational still lifes — her sense of color was already remarkable.

During 1925, Amanda had occasional lessons with Sidney Bell, who came from England and painted portraits in the tradition of the Royal Academy. Those lessons and the 1917 classes at the Portland Art Museum were the extent of her formal art instruction. Throughout her career, she learned primarily by doing, by exploring on her own. Her style evolved into a vigorous impressionism, and she later became interested in abstraction. But her work does not fall into neat "periods." She was absorbed in several styles concurrently, moving back and forth, for example, from an abstract form made of sewn pieces of burlap to an impressionistic study of sunflowers in collage or a life-like portrait in oil.

REALISM

From about 1926 to about 1938, Amanda painted many still lifes, in oil and pastel, some portraits, and a few landscapes. In 1931, she entered a floral still life in an exhibition of the Oregon Society of Artists. It won the blue ribbon in its class. The next year, her work was first seen at the Portland Art Museum, in a show called "Artists in Portland and Vicinity." From then on, her works were part of many shows: the spring and fall exhibits of the Oregon Society of Artists (from 1931 through 1944), the American Artists' Professional League's annual shows (1932 through 1936), and the Oregon State Fair art pavilion (1933 through 1937). Almost every piece she entered won a first prize — 23 blue ribbons during those years. Sometimes she had two or three works in one exhibition, in different categories. In later years, a principal outlet for her paintings was the Rental-Sales Gallery of the Portland Art Museum. From 1966 to 1985, about 150 of her works were there.

This public appreciation was gratifying. Creative people produce their work because they love doing it — indeed, are driven to do it — and their first aim is simply to materialize their inspiration, to please themselves. But even

the most independent and self-propelled creator is not utterly indifferent to public approval. Amanda was encouraged by the blue ribbons and the favorable reviews. Also at this time, she began to have a following — admirers of her work who visited her home studio and patrons who bought her paintings. She did not have to sell anything in order to follow

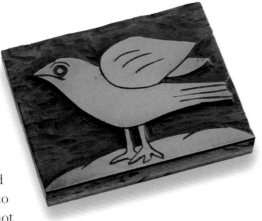

her vocation. Edmund was a good provider, and she could paint what she wanted in whatever way she liked. But it is not unpleasant to find that the public are prepared to pay for one's work. Often, however, if a visitor obviously liked a painting, Amanda would give it away, sufficiently rewarded by having it in the possession of someone who truly understood and appreciated it and who felt the emotion she sought to transmit.

Amanda derived pleasure from the visits of artistic friends and patrons, but she did not go out much or attend many public functions. As a result, she came to be regarded as something of a recluse. It was not, however, that she was anti-social. She had what she called "dizzy spells." One doctor put it down as simply "nerves." Eventually, another doctor correctly diagnosed it as Miniere's disease, a disorder of the inner ear that caused severe and sometimes prolonged dizziness. The attacks were quite unpredictable, and there was then no effective treatment, except to lie down. The fear that such an attack might occur in a public place kept her at home, even on an opening night at a gallery show of her own work. To see the shows of her work, she would sometimes go to the gallery with a friend or relative at some early morning hour when no one was about.

Also, by disposition, Amanda did not care for large crowds or conventional "happenings" such as cocktail parties or teas. She liked people in small numbers, where friendly and sincere conversation is possible.

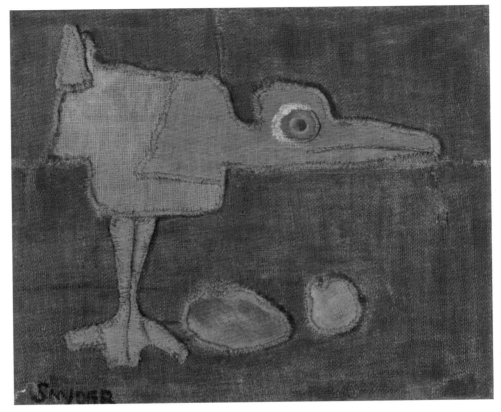

MANDA BIRD, 1957
Amanda Snyder
Burlap collage, 25" x 29"
Collection of Hal and Jeanyse Snow

The Miniere's attacks bothered her most from the 1930s into the 1950s, gradually diminishing in severity. But even with that handicap, Amanda was productive. She painted almost every day, often working on two or three pictures alternately. She also spent time gardening, sewing, making braided rugs and quilts, canning fruit, and enjoying all the other household activities that helped make her a good wife and mother.

Perhaps because she was more homebound than most people, she often found the inspiration for her pictures in and around her house — flowers, birds, trees, and landscapes she could see from her own home, which was on a hilltop with extensive views of hills and mountains. As she expressed it, "My inspiration comes from shapes and colors. I see beauty and design in 'every-day'

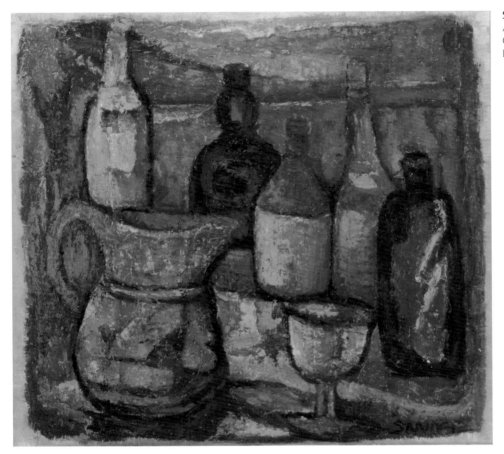

things, in my home and garden. My greatest pleasure is to produce paintings which communicate a love of simple life, expressed in a simple manner."

Amanda had many friends among the city's artists, including C.S. Price and Charles Heaney. They visited her occasionally. Neither of them had an automobile, but they would manage on the bus. They would sit in her basement studio, look at her current work, and discuss art.

In 1939, Amanda's mother, Della, came to live in the Snyder household. She had been a widow for 15 years, living in Roseburg, where she had another daughter and a son. She stayed with Amanda's family in Portland until she

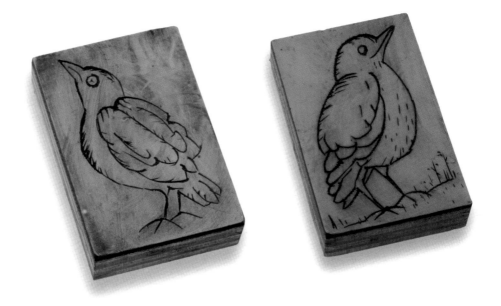

died, in 1966, at the age of 93. She was a great help to Amanda, not only in the kitchen but also as a daytime companion when the other members of the family were out of the house.

DOLLS

In 1942, with the tensions and sadness of war — Amanda had a brother and a son in military service — she found relaxation in making a family of dolls. She sewed them, carefully attending to the smallest details of clothing. Then, as she recalled, "The idea of making sketches of them in human situations and childish activities became insistent. From the first sketches, the dolls became living actors in my imagination." These patient and tireless "sitters" could provide subject matter when no living model was available. From 1942 to 1950, Amanda did about 20 such pictures. The idea worked so well that she later went on to make life-size mannequins, which not only could "pose" for paintings but also became works of art in themselves.

On one of C.S. Price's visits to Amanda's home studio, he said, "Some of your work reminds me of the paintings of Rouault." He was looking at her

religious paintings and some of her portraits, with the figures or features outlined by strong black lines. She was not very familiar with Rouault's work but did some research and found that she liked him and his work very much. The two of them, moving quite independently and without any contact whatever, had arrived at a somewhat similar destination. She wrote to Rouault in Paris, and they exchanged greetings through his daughter, with whom he lived. Amanda sent him one of her clown dolls.

Rouault, appreciative and quite touched, sent her a photograph of himself with his signature. It became one of her most prized possessions, and she posted it in her studio near her easel. Amanda said: "There are only a few people living at the same time as ourselves with whom we really have a deep common feeling, a similar view of the essence of life, a comparable urge to try to express it. And most of them we don't get to meet."

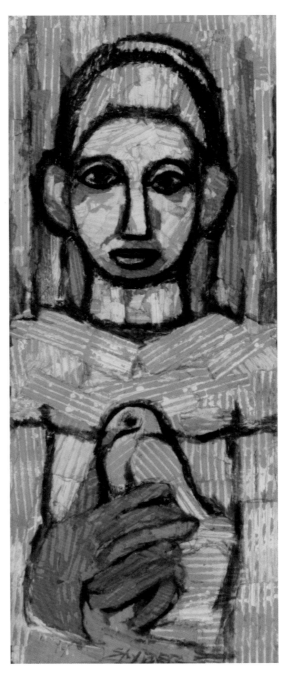

YOUNG SAINT, ca. 1966
Amanda Snyder
Paper collage, 28" x 11"
Collection of Michael W. Foster, Astoria

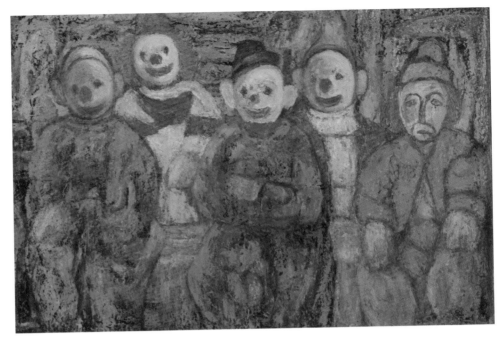

CLOWNS

In 1943, Amanda began a long series of paintings of clowns and the circus. Clowns appealed to her — their colorful and picturesque clothing, a sense of happy make-believe, all set in the fantastic theatrical world of the circus. The show in the "Big Top" would open with a fanfare by the band and a welcome by the Master of Ceremonies, addressed to "Children of All Ages." There is something about the circus and its clowns that is child-like, but with an undercurrent of pathos and wistfulness. It was that combination that Amanda sought to capture on canvas.

Amanda also loved the circus for the casual activities in the back lot, where clowns relaxed among the brightly colored circus wagons or gathered around the kitchen wagon. Her brother, Redford (known as "Red"), or neighborhood friends would drive her to the circus lot, where she made many quick sketches.

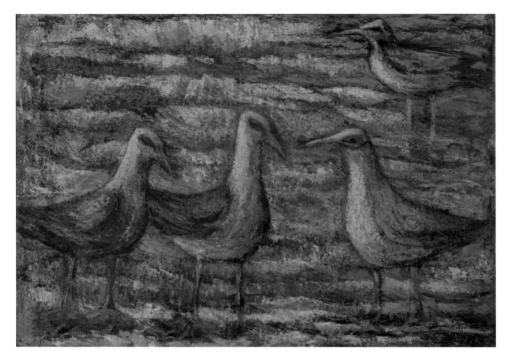

GULLS, ca. 1967
Amanda Snyder
Oil on board, 35" x 47"
Private Collection

BIRDS

About the time Amanda began to do work on the circus theme, she started another series: birds. Here was a subject that was convenient, because the birds came to her. Her spacious yard and garden were always full of birds, including seagulls (the house was close to the Willamette River). And the bird personality was congenial to her: baby robins, small and helpless in their nest; playful birds; perky birds. The bird form, graceful and aerodynamic, was pleasing. Just as Amanda could use doll mannequins to portray human feelings, she could anthropomorphize bird behavior, seeing in the birds human feelings, traits, and foibles. She did some small paintings of birds from 1946 to 1948 and then, in 1949, a large and powerful oil, *Honeymoon*. Her success with that painting encouraged her to pursue the bird theme. She began a great outpouring of bird pictures that continued for the rest of her life — so much so that some people thought of her as primarily a bird artist.

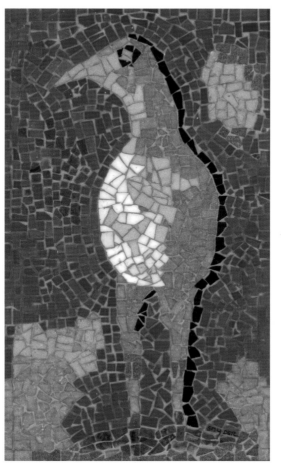

She rejected that label, reminding friends and visitors that she painted many things besides birds.

One of her bird friends was a seagull who often came to her yard over a period of about three years. She identified him by his particular marking. She named him "Mike," and he was the subject of several works, including *Mike, The Seagull*, a tile mosaic she created in 1952.

SELF

Most artists have done self-portraits. The subject is convenient, always there, and the view in the mirror may convey or inspire an emotion. Amanda did 20 pictures that are classified as "self." One's first impression, on looking through them, is that the artist was quietly somber. That is likely to be true of any artist's self-portrait. It is natural that the face will be in the resting mode. For the artist to produce a brief smile on glancing in the mirror and then return to the serious resting appearance to work on the painting would be too forced, too artificial. Catching a candid fleeting smile is the province of photography. An oil portrait portrays the basic personality, at rest.

Someone — after many years of the usual joys, struggles, and disappointments — said life's journey is made up of laughs, smiles, sighs, and tears, with the sighs predominating. Amanda might have agreed.

ABSTRACTS

Amanda did more than 80 works that are classified in her inventory as "abstract." The use of that word can be somewhat arbitrary. An "abstract" may be representational but with all the nonessential details omitted. In other "abstract" paintings, all recognizable features may be abstracted away. It has become nonrepresentational. The hope is that the forms, colors, and composition will transmit to the viewer the emotion the artist felt. Amanda did both kinds.

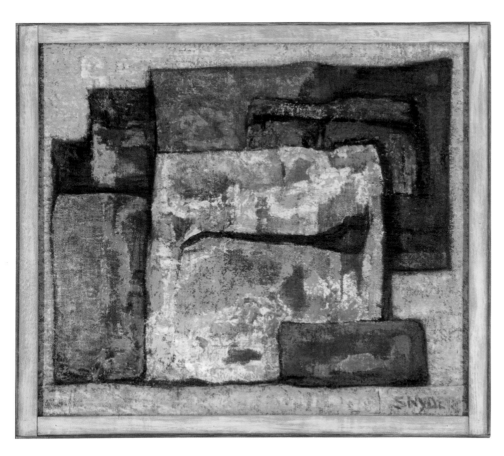

ABSTRACTION #4, ca. 1965
Amanda Snyder
Oil on burlap, 33" x 37"
Collection of John Gray

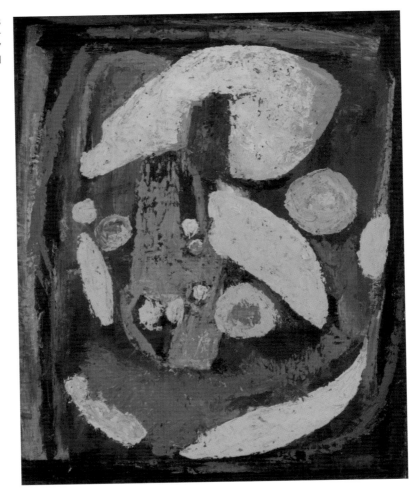

Amanda's abstracts show a great variety of materials and methods: pieces of sandpaper for a collage, burlap sewn on cloth, oil paint on burlap, the encaustic effect of heat on crayon. Such resources gave Amanda's imagination great scope, showing her originality and daring willingness to experiment. Her abstracts span 25 of her most productive years. She had more ideas than time. Her mother would tell her to "slow down," to which she would reply, "I am never going to slow down." And she did, indeed, paint pictures up to three or four months before her death, in 1980, at the age of 86.

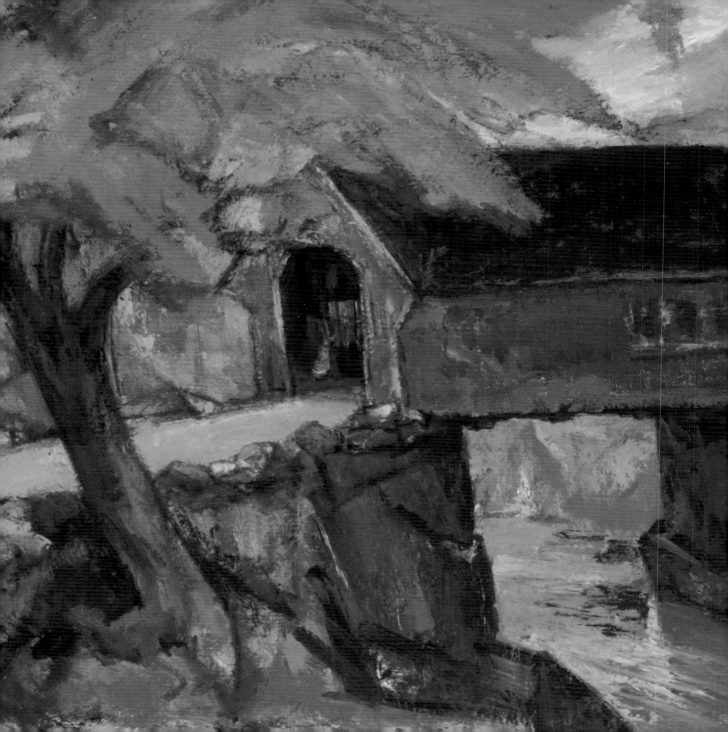

Jefferson Tester

By Eugene Edmund Snyder

Jefferson Tester's artistic talents blossomed when the Tester family moved to Roseburg. Jeff's friends and teachers were impressed with his great gift for drawing, and they urged him to go to art school. But neither he nor the family had enough money to pay for it. An acquaintance in Roseburg became his benefactor; and when Jeff graduated from high school, the man paid his tuition for one year at the San Francisco School of Art. In 1919, at the age of 20, Jeff became an illustrator for *The Oregonian*. In those days, newspapers often used pencil or ink drawings of the people in the news, and the newspapers from 1919 to 1926 contain many impressive examples of Jeff's work.

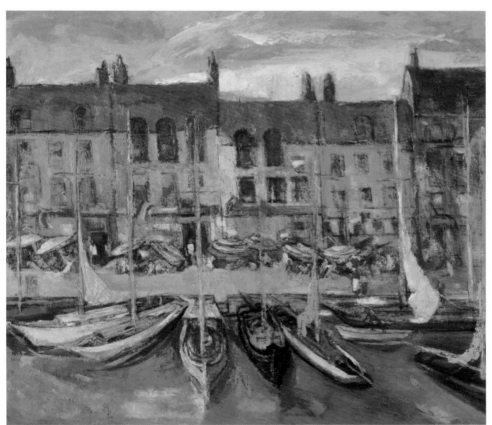

SOUTHERN FRANCE - ST. TROPEZ, ca. 1952
Jefferson Tester
Oil on canvas, 36" x 42"
Private Collection

Previous Page
RED BRIDGE, ca. 1965
Jefferson Tester
Oil on board, 18" x 24"
Collection of Bill & Ann Swindells

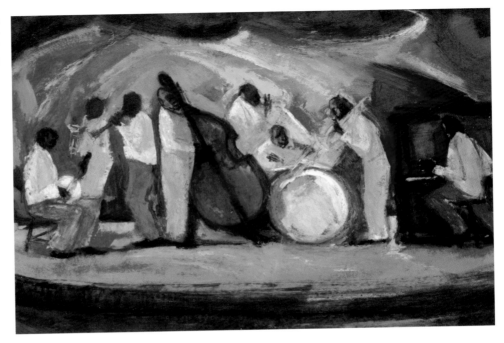

In 1925, Jeff and his sister Amanda took art lessons from Sidney Bell, an English artist who had moved to Portland and who painted portraits in the style of the Royal Academy. Bell was much impressed by the two siblings, and told them: "Somewhere in your Tester family background there is a great English painter."

Bell was so encouraging that Jeff left his newspaper job in 1926 and spent a year at the Chicago Art Institute. He then felt ready for the Big Move — to the hub of the art world, New York City. Jeff was not without ambition, and he knew he was good. He opened a commercial art agency. He did so well that by 1934 he and his wife were living in a large suburban house with a maid. It was a gratifying change from his struggling, though not unhappy, teenage days.

In commercial art, Jeff's clients included some national and international corporations. Portraits by Jeff appeared in many publications and on the cover of *Time* magazine. But he was gradually spending an increasing share of his days on fine art. In the 1930s, he knew several New York artists, including Franklin Booth, George Oberteuffer, and Jonas Lie.

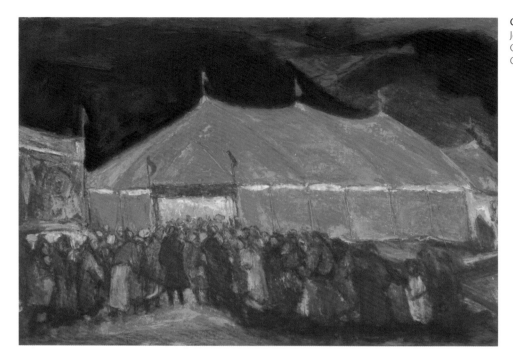

Every year or so, Jeff would visit Oregon. He felt a family connection with his two brothers and two sisters, and he would visit his mother, now a widow. "Ma" was the strong character who held it all together. Jeff never wrote letters, but to his three nephews in Oregon he personified the rich uncle who had done well in the big city.

Jeff was a raconteur who could tell stories and describe events entertainingly, but his domestic life was not so successful. Perhaps his only real happiness was in painting pictures.

In November 1944, Jeff had a one-man show at New York's Babcock Galleries — 22 canvasses of great diversity. The reviews were enthusiastic. One called the show "an unusually auspicious debut…[that] leaves the visitor with an indelible impression of individual style." Another called Jeff "a painter of most surprising ability and strength…[with] skill at composing pictures solidly…[he has] quiet wit…[and] a brilliant sense of color." As a result of that exhibition, Jeff was invited to enter his work at a "Critics' Choice" show at the

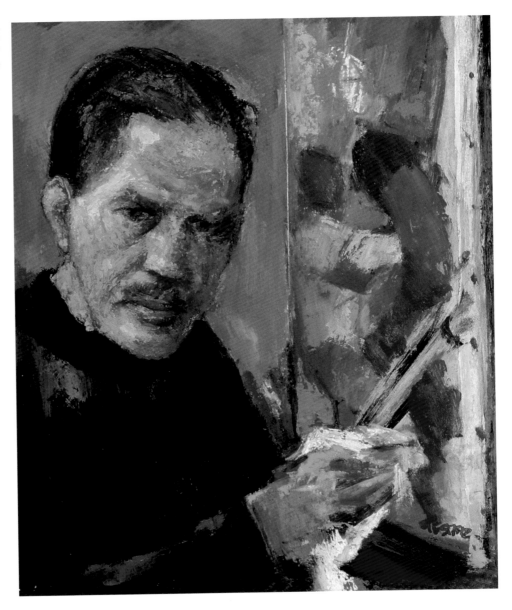

New York Armory in 1945. His pictures shown there prompted Howard Devree, the art critic for the *New York Times*, to call Jeff "one of the ten most outstanding contemporary painters."

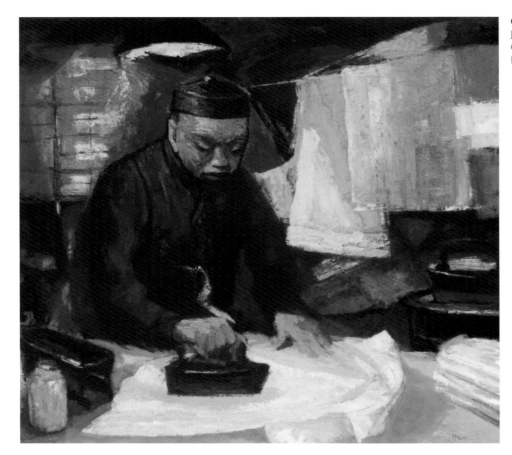

CHINESE LAUNDRY, ca. 1955
Jefferson Tester
Oil on board, 30" x 34"
Private Collection

During 1950-1952, Jeff traveled to New Orleans, Mexico, the West Indies, and France. Wherever he went, he did paintings of the local scenes — a New Orleans jazz band, women washing clothes in a Mexican river, sugar-cane cutters in Cuba. He had a one-man show in Paris in 1952 at the Weil Gallery. It produced some very complimentary reviews. One critic wrote: "It marks one of the best American painters known to us today, one who does not repeat a lesson drawn from our own or other's paintings, but boldly asserts a happy personality." Another: "Here is more than a promise; it is a finished realization, a beautiful chapter of quality." And another: "Tester endeavors to find his picture's strong lines. Knowingly, he gives them rhythm, robustness of color,

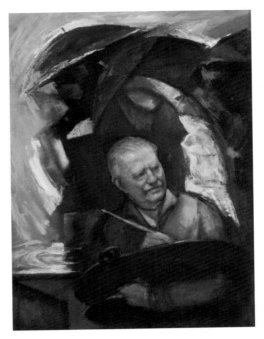

and an earthy-rich palette, and energy of style…which are not only forceful and moving but also executed with discipline."

In 1963, following a divorce, Jeff decided to return to Oregon, where he met an old friend from high school days, Stella, who was now a widow. They got along well together, and in October 1963 they were married. They moved into a house in Lake Oswego. It was a stable home setting that gave Jeff nine prolific years of painting. Jeff died on January 18, 1972.

He left a lifetime's work of many paintings, which fall quite naturally into two distinct groups. One is portraits, of which he did many — a great diversity of subjects and mediums, from ink drawings to full-length formal oil paintings. The other group includes landscapes and scenes of people, occupations, and ways of life he saw in different places — a group of people with umbrellas on a rainy day in New York City, clam diggers on an Oregon beach. In these paintings, he sought to achieve a unity, to bring all the elements together into a unified composition. He wanted the picture to make one single impression, one statement, so the viewer is aware of one message, one shared emotion.

Frank Kinkaid (1922-1994) was the Chief Art and Theater critic for CBS (KOIN) TV news in Portland during the 1960s and 1970s. Over that time, he interviewed hundreds of celebrities for CBS, as well as for *Opera News* magazine. The following excerpted text is from a broadcast made shortly after Jefferson Tester died in 1972, based on an interview with Tester's widow, Stella, and Kinkaid's own reaction to Tester's art.

Jefferson Tester – His Own Man

By Frank Kinkaid - KOIN TV News
Aired late January 1972

I never met Jefferson Tester. I had planned to next month, when his art was to receive a rare showing in Portland. But on January eighteenth, Tester was stricken and died. A week later; I went to his studio, which has been left exactly as it was on the last day he painted. In fact, the pigment in his mixing tray is not yet hard.

Tester was not a native Oregonian, but he spent his youth in Roseburg. Then [he went] to Portland, where he worked in the art department at The Oregonian. *It was many years ago and he was very young, but [he] still [had] a native gift for illustration.*

He was a superb illustrator, and did numerous covers for Time *magazine during his years in New York and for the* Saturday Evening Post.

He left Madison Avenue and, like other artists before him, headed for the tropics, in his case, southern Mexico. Before he left New York, he had begun to paint society portraits; but in his desire to paint the world as he saw it, this didn't fit into his life either.

In Mexico, he married an heiress. And, from a yacht, he traveled the world, painting. In New Orleans, he was fascinated with black jazz musicians and painted them in profusion. Most sold at once.

The south of France followed, and his reputation as an American Impressionist began to grow. His canvases began to glow with the warm colors of France. In 1952, he had his first showing in Paris. The art critics from the Paris press — and they have seen it all — hailed him as a major American talent. Again, his warm canvases began to sell on the world market.

But there is an inner compulsion in artists to paint, not to be salesmen or businessmen for any length of time. Painting is an obsession, and the world beckoned.

In 1963 he returned to Oregon, built this studio, and married again — this time to his childhood friend, Stella. If you wanted to buy a Jefferson Tester then, you had to come here to the studio and talk to the artist in person. Usually, he was painting Oregon. He found the vigor of our state appealing, and canvas after canvas followed sketches made on countless trips around the state.

There has not been a showing of Tester's work in Portland for years, and never at the [Portland] Art Museum. But his paintings sold, and now only about a hundred remain from all of his periods...from age nineteen to age seventy-two.

Preparing for a long-awaited exhibit, he suffered a stroke and died on the eighteenth of January.

But in this studio, one can see that Oregon has lost an important talent, and this is always a loss that is hard to replace.

In looking at these pictures today, these pictures by Jefferson Tester, I'm reminded of another artist who spent his last days in Oregon...the composer Ernest Bloch. Like Jefferson Tester, Ernest Bloch found great success in his youth in Paris and in the other European capitals. But perhaps the fertile ground of Oregon made his art great, as it has Jefferson Tester's.

Is Jefferson Tester a great artist? I don't know. I certainly like his paintings and would like them to be on my own walls. But as to the question of is he a great artist, was he a great American artist, the answer will have to come in future years.

This is Frank Kinkaid.